The Bill of Rights
The First Ten Amendment

Everyone Should Know
For Kids

Written and illustrated by:

Jeremy Kimmelman

Copyright © 2015 Jeremy Kimmelman

All rights reserved.

ISBN: 13:978-1519265586

ISBN-10:1519265581

Copyright © 2015 by Jeremy Kimmelman
All rights reserved. This book or any portion thereof
may not be reproduced or used in any manner whatsoever
without the express written permission of the publisher
except for the use of brief quotations in a book review.

Printed in the United States of America

First Printing 2015

For information on bulk purchases or corporate premium sales, and or

academic sales please contact author: jkimmelman@hotmail.com

For further faster access to my next books, please add yourself to my email mailing list.

Acknowledgments

Thanks to my family for all their support, James, Ken, Norma and for reviewing and assisting with editing. Also, thanking my friends who supported me as well.

Introduction

The Bill of Rights? What is it?

When the United States of America was created, over two hundred years ago, a group of very gifted, wise, and powerful men got together in order to form a new government. There needed to be laws to maintain order so this new land could thrive!

The "founding fathers," as they are called, wrote the constitution of the United States of America. This was to guide us as to how our new government would work. Three branches of government were created: The President, the Congress, and the Supreme Court, and they would work together and would have a balance of power to justly enforce laws to make them fair for everyone. When they first wrote the constitution, it was only about how the government would run, but it didn't include rights for the individual citizens.

So they got together again and wrote the first ten amendments, which they added to the constitution. The first ten amendments are what is called the Bill of Rights. These were basic human rights written to protect every individual citizen.

The constitution was written beautifully and with great care, and the goal was to protect all of its citizens! I hope you will enjoy the book and learn what these rights really mean for each and every one of us!

As a citizen of the United States it is very important to know and understand all the rights that were created for you!

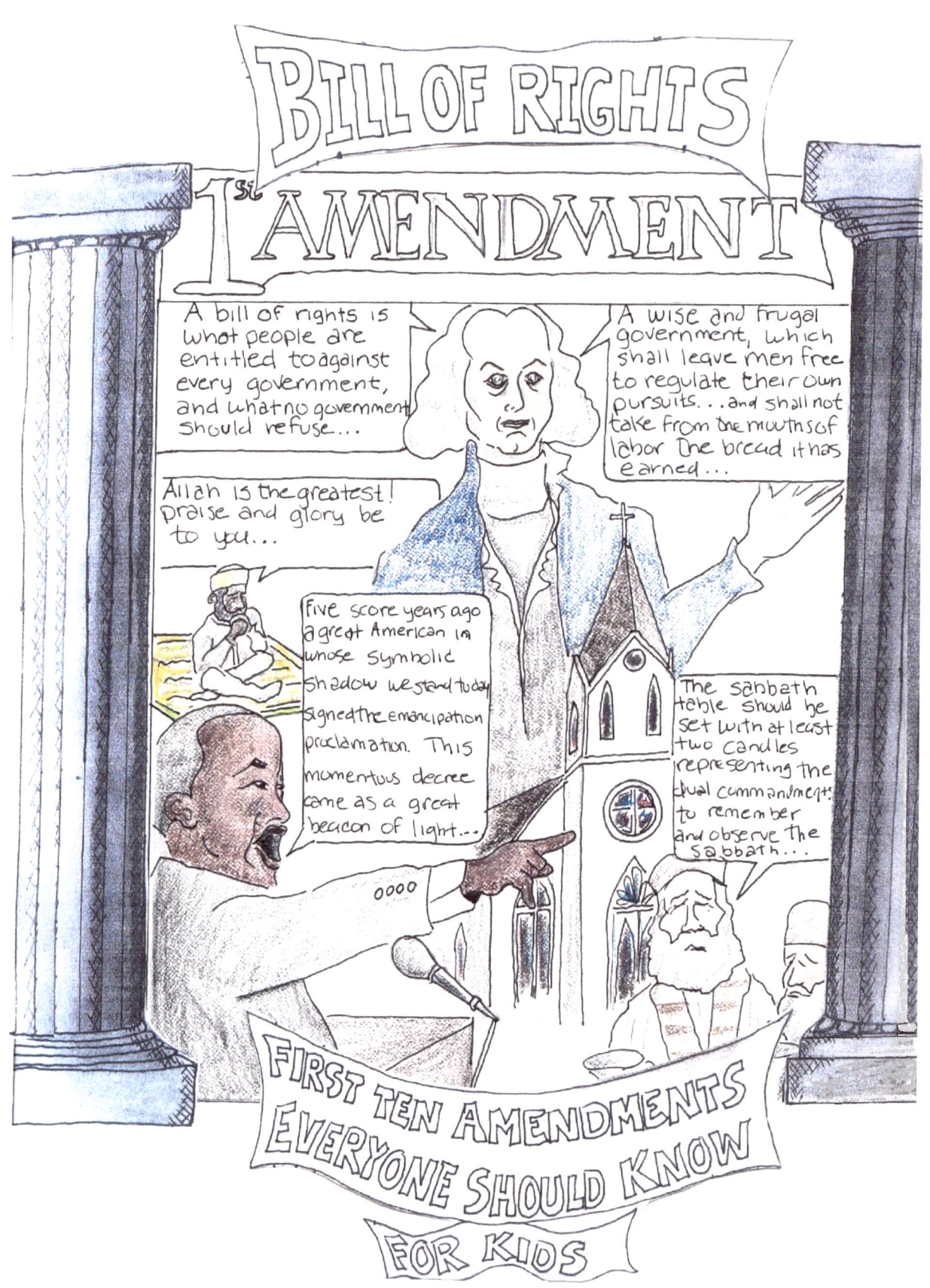

The First Amendment

The First amendment is one of our most important! The First Amendment covers four main areas that affect us as citizens directly. The first of these areas is freedom of speech, the second is the area of freedom of assembly, the third is freedom of the press, and the fourth is the freedom of religion and the establishment clause.

We will start with the freedom of speech! Every citizen has the right to free speech in the United States. The government cannot interfere with any individuals' right to speak his opinion or express himself.

There are some exceptions though, where certain speech or conduct would harm others. For example, starting a big riot, where people would get hurt, so that is not allowed. So, as long as your opinions, expressions, or conduct, doesn't hurt others you have this right!

You also have the right not to speak. For example, if the state you live in has the state motto on their license plates, like California whose state motto is, "Eureka", you do not have to use the state motto on your personal license plate if you do not want to. So enjoy your right to free speech!

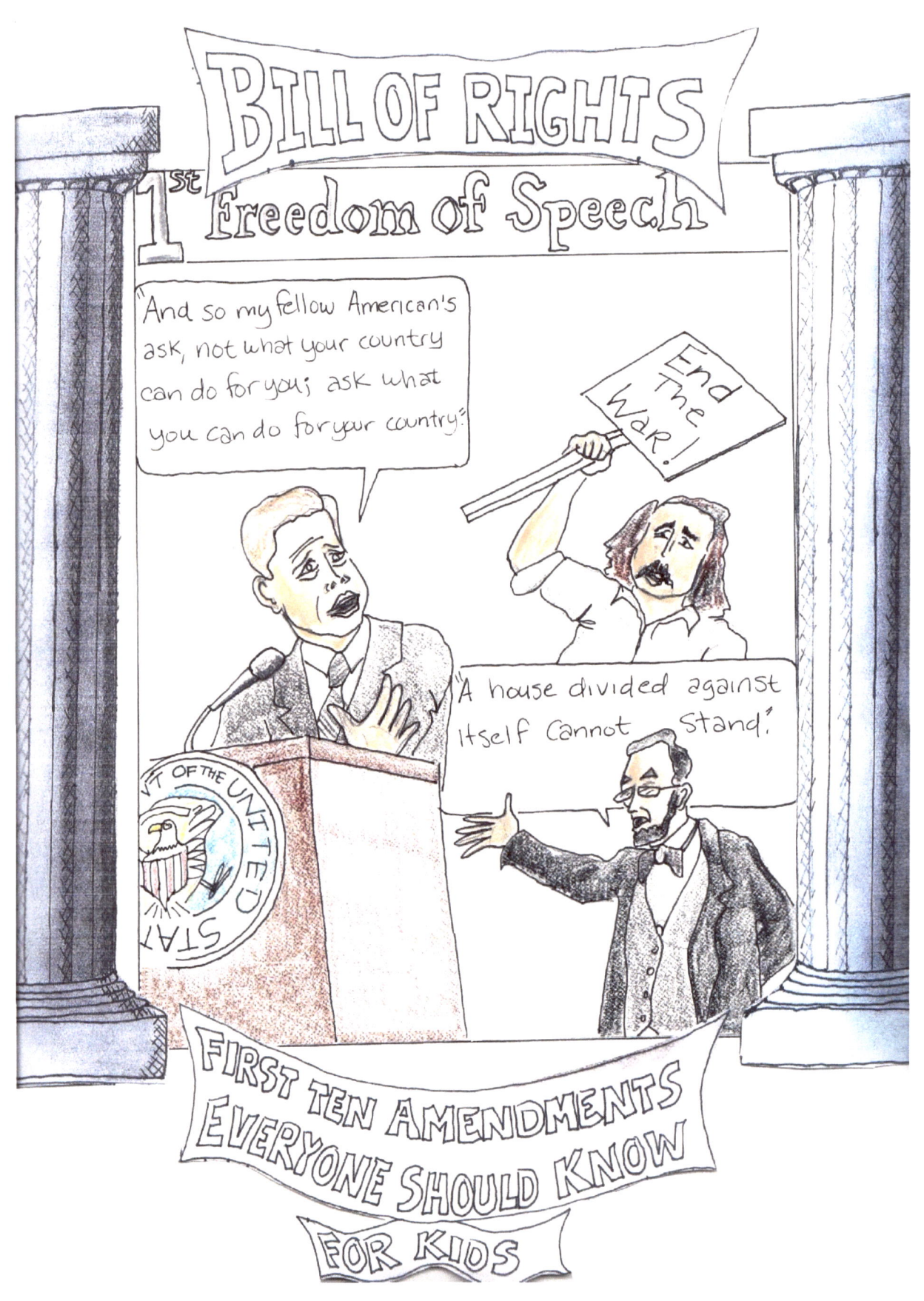

The First Amendment
(Freedom of Assembly)

The second part of the First Amendment is the right of the freedom of assembly. This means you have the right to assemble as a group and march for whatever causes you believe in or whatever unjust things you want to stop. For example, a protest to end the war!

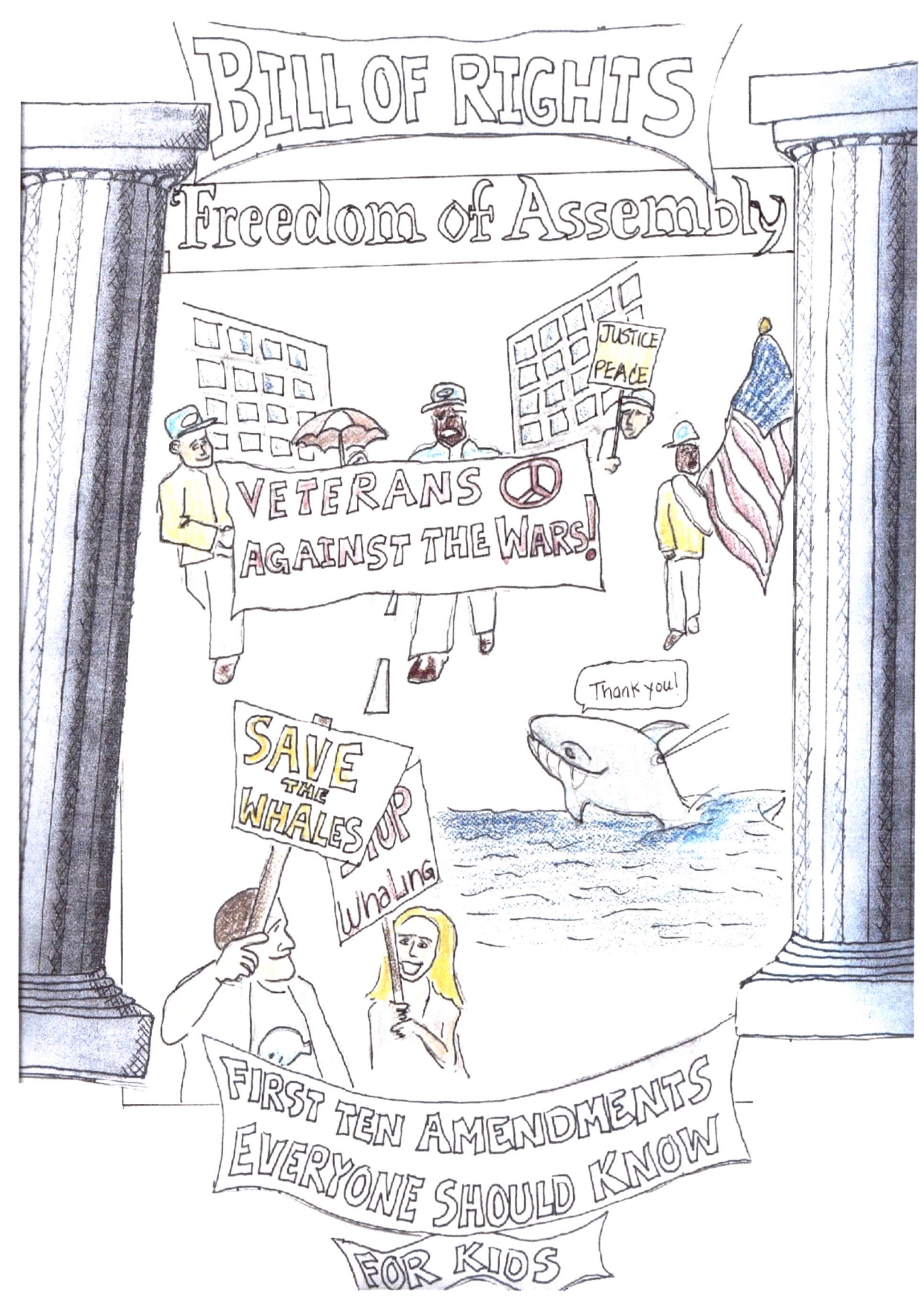

Citizens got together and protested to stop many injustices, like ending the war. In the 1960's groups got together and marched demanding the right to be treated equally no matter what race, ethnicity, or culture they were!

You can see these marches go on today all over the nation where people feel there are injustices going on and they get to be heard! As long as the groups are doing it peacefully, and do not bother people that are working or are around the area this is your right!

The third area of the First Amendment is the freedom of the press! When you watch the news you are watching the press practice their right to report on stories that are happening all over. The news media has the same right of free speech as citizens do to report all the important events that are going on that people need to know about.

So when you watch the news you are getting the freedom of the press to report to you so you know what is happening!

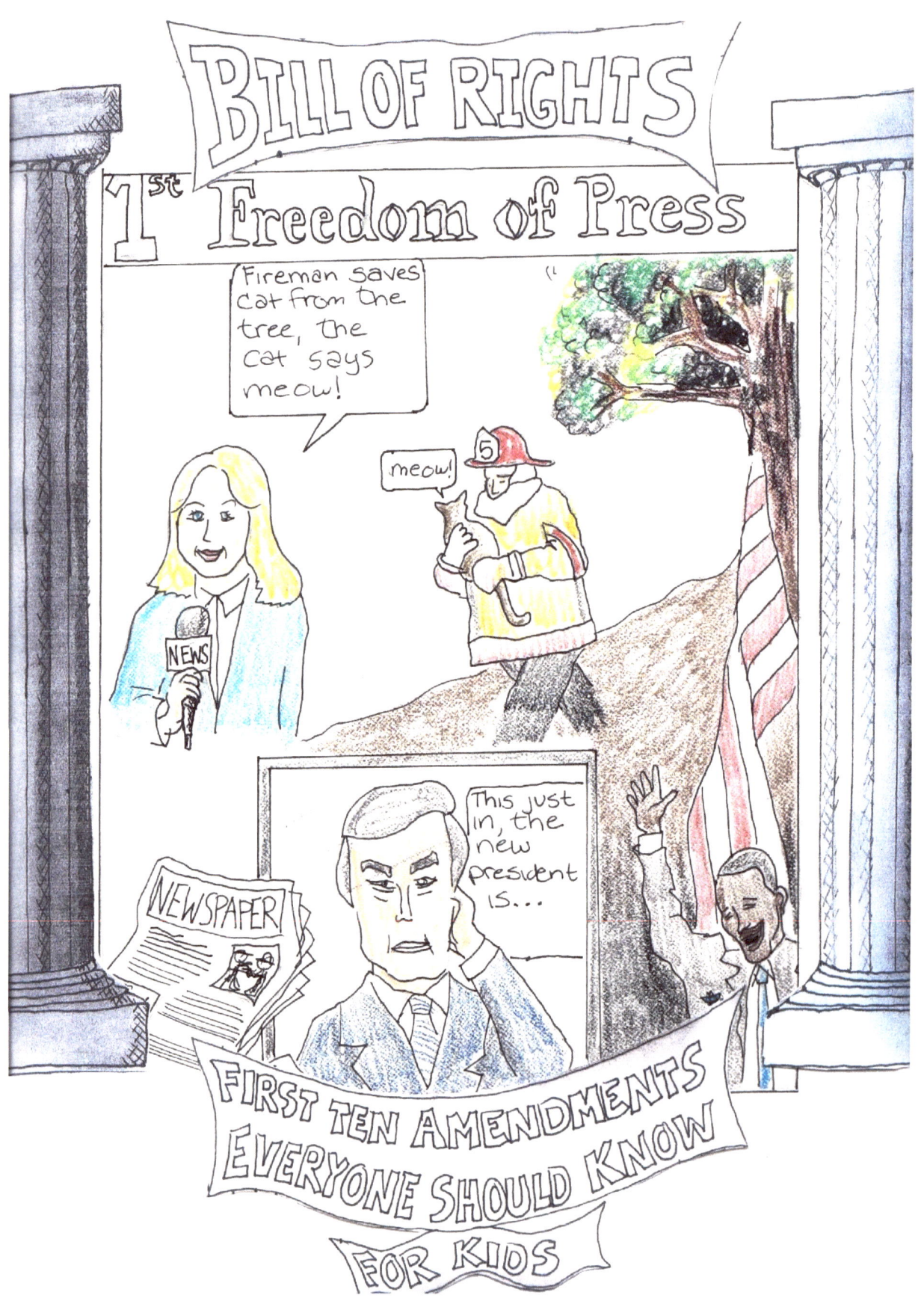

First Amendment

(Free Exercise Clauses)

The last area is very important to you as a citizen; this is the freedom of religion and the establishment clause. The freedom of religion gives you the right to be and practice whatever religion you want and no one can try to stop you. This is a big reason the United States is such a wonderful country because all the people can practice whatever religion they want and in peace. When you see churches, temples, mosques, this is because we all have the right here to be free and worship our religions!

The other part is called the establishment clause. This means that the government cannot establish a religion or support any religion. The government must respect the rights of different religions and not interfere or support one over the other.

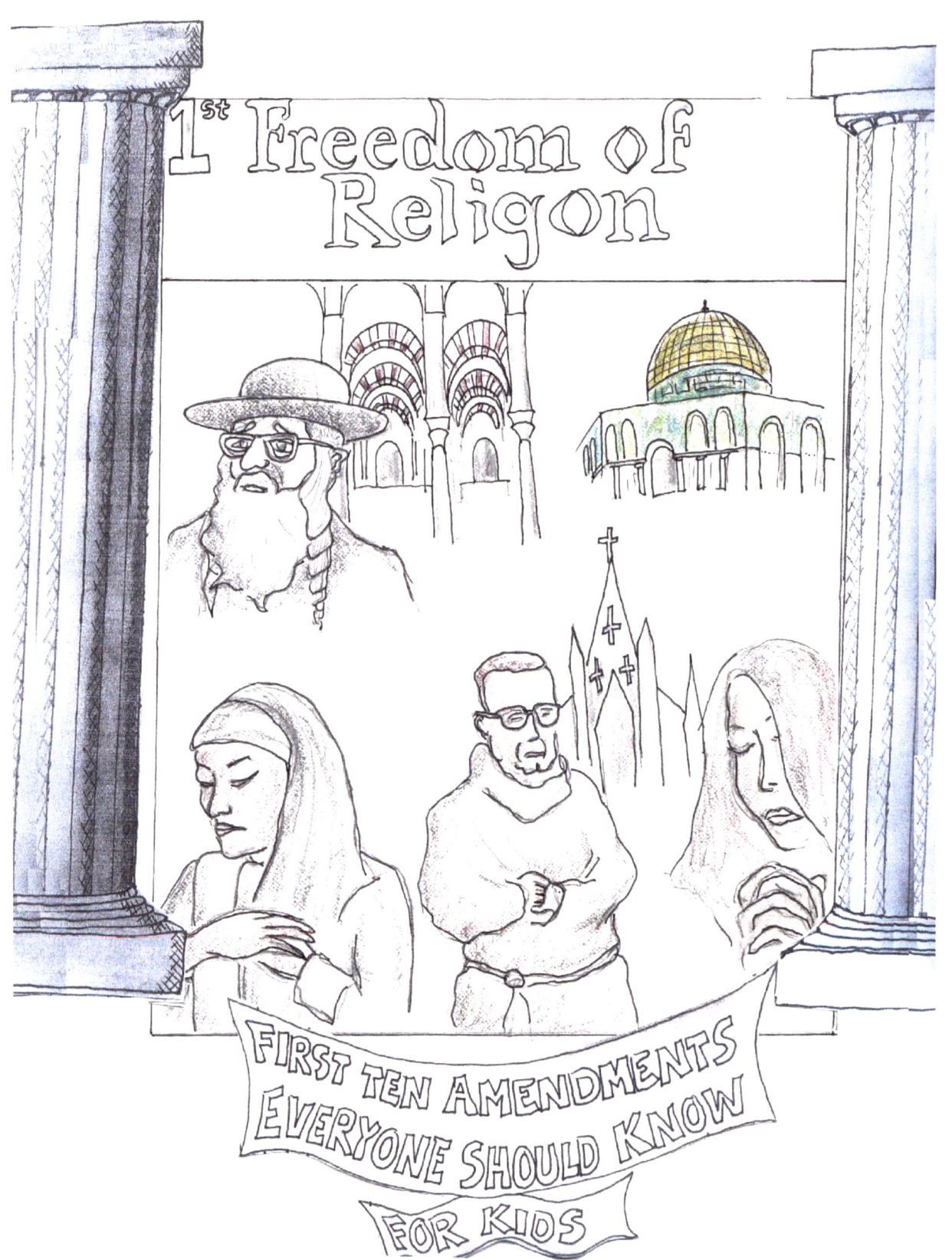

The Second Amendment

This amendment was created to protect all the citizens with our military forces. If there is an invasion from any alien power our military will protect us. Also, this gives people the right to bear arms meaning certain responsible people can own a gun for protection in their homes in case an intruder tries to break in to protect themselves and their family!

Lastly, the Second Amendment was created for individual citizens just in case they ever have to protect themselves from government tyranny!

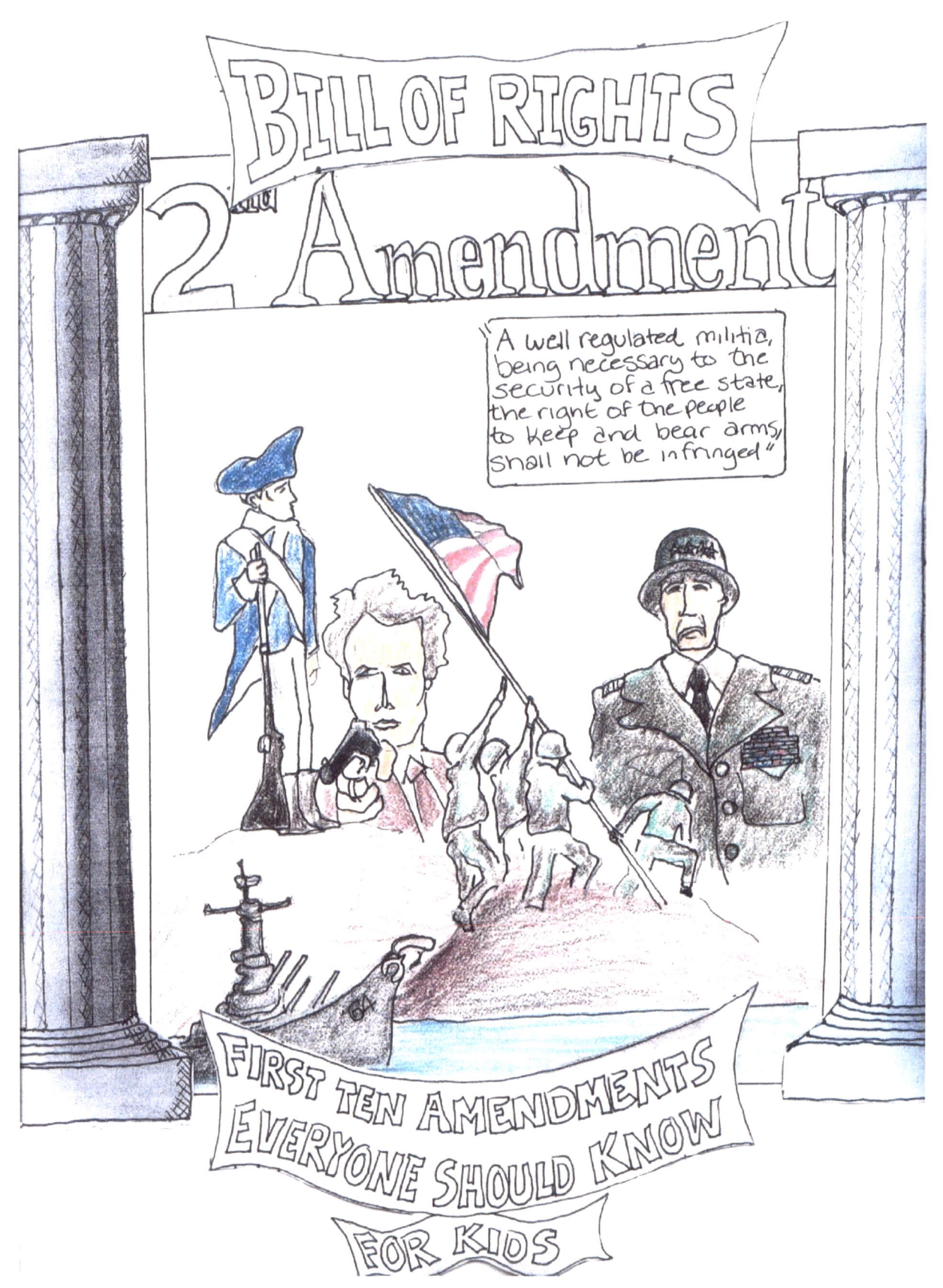

The Third Amendment

This amendment was created out of the American revolutionary war to stop soldiers from being able to enter private citizens' homes and stay there for the night. The owners must give them permission!

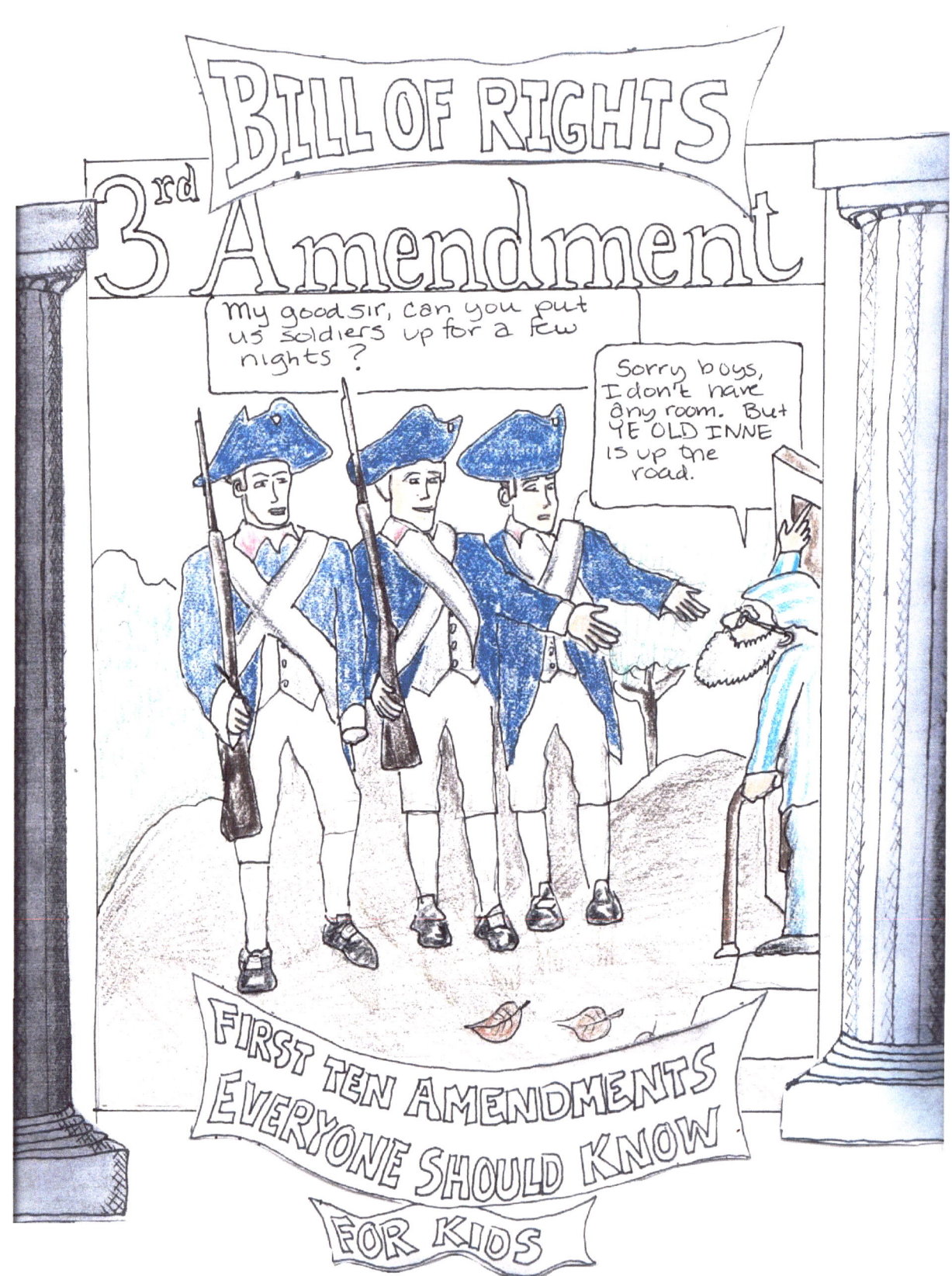

The Fourth Amendment

The Fourth Amendment is also a very important amendment. This amendment makes sure that citizens are not arrested unreasonably nor have their homes searched unreasonably, unless the police have a warrant to do this! This is to protect citizens from being arrested or having their homes searched without good reasons. There are many emergency exceptions though in many cases. For example, a bank robber driving to get away, or to go in someone's home to save them if there is an emergency.

But generally, the police have to obtain an arrest warrant or search warrant first before they can arrest someone or search them. This means they have to be reasonably certain someone has committed a crime or there is criminal evidence in his home and then they ask a judge for the search or arrest warrant and it must be signed in good faith by the judge or the magistrate.

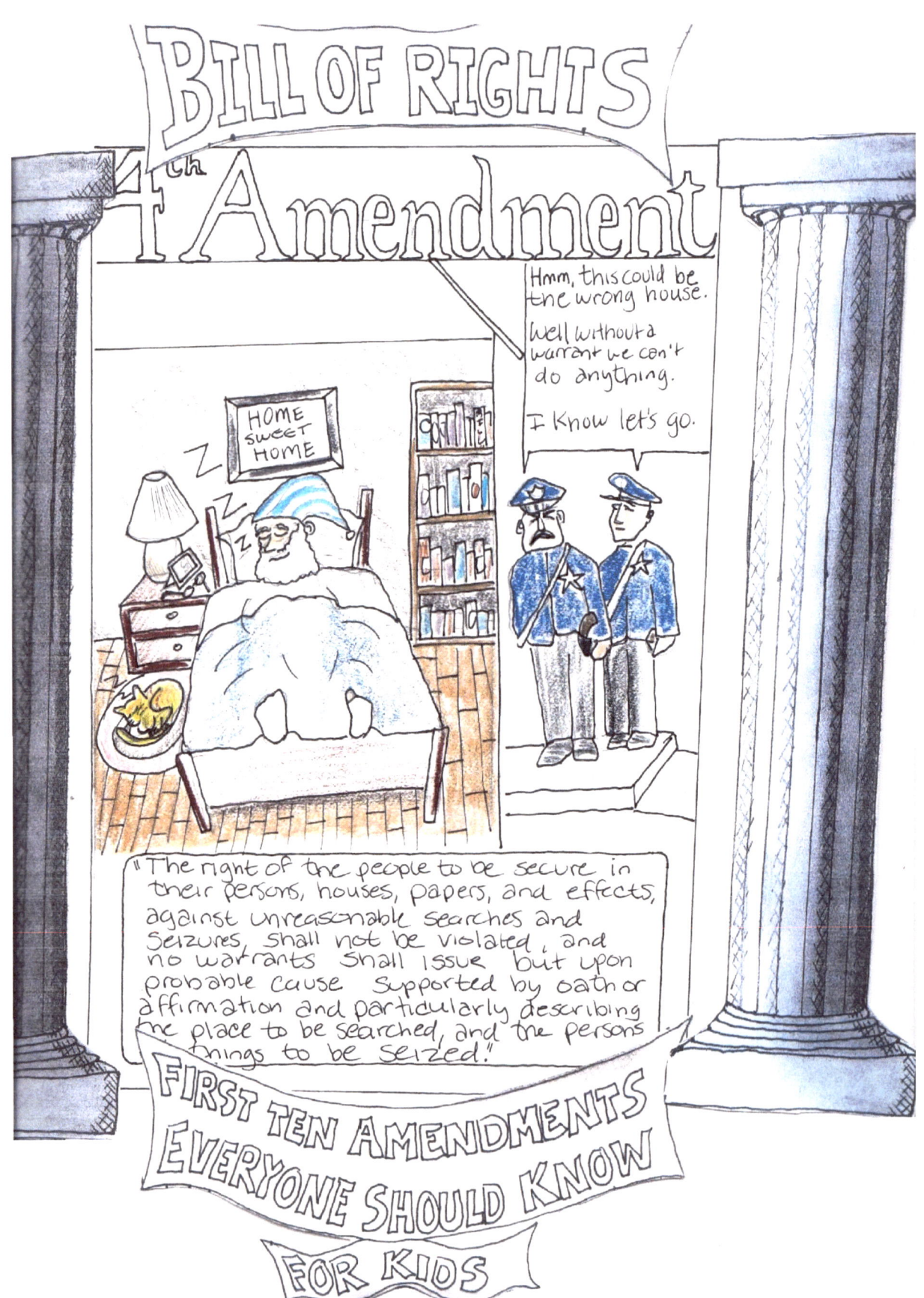

The Fifth Amendment

The Fifth Amendment has to do with the right not to self incriminate and double jeopardy. The right not to self incriminate is for the protection of someone who is being questioned on the witness stand about whether they committed a crime or not. That person on the witness stand can say," I take the Fifth Amendment" meaning he doesn't have to answer because the District Attorney has to prove that he did the crime.

Also, sometimes the police may think the person committed a crime but they are not sure. This means when the police stop someone who they may think has committed a crime they will ask them questions to find out if they did it or not. So, we as United States citizens, if we get stopped and are suspected of a crime, we have the right not to answer any questions and also have the right to have a lawyer with us when the police question us for our protection.

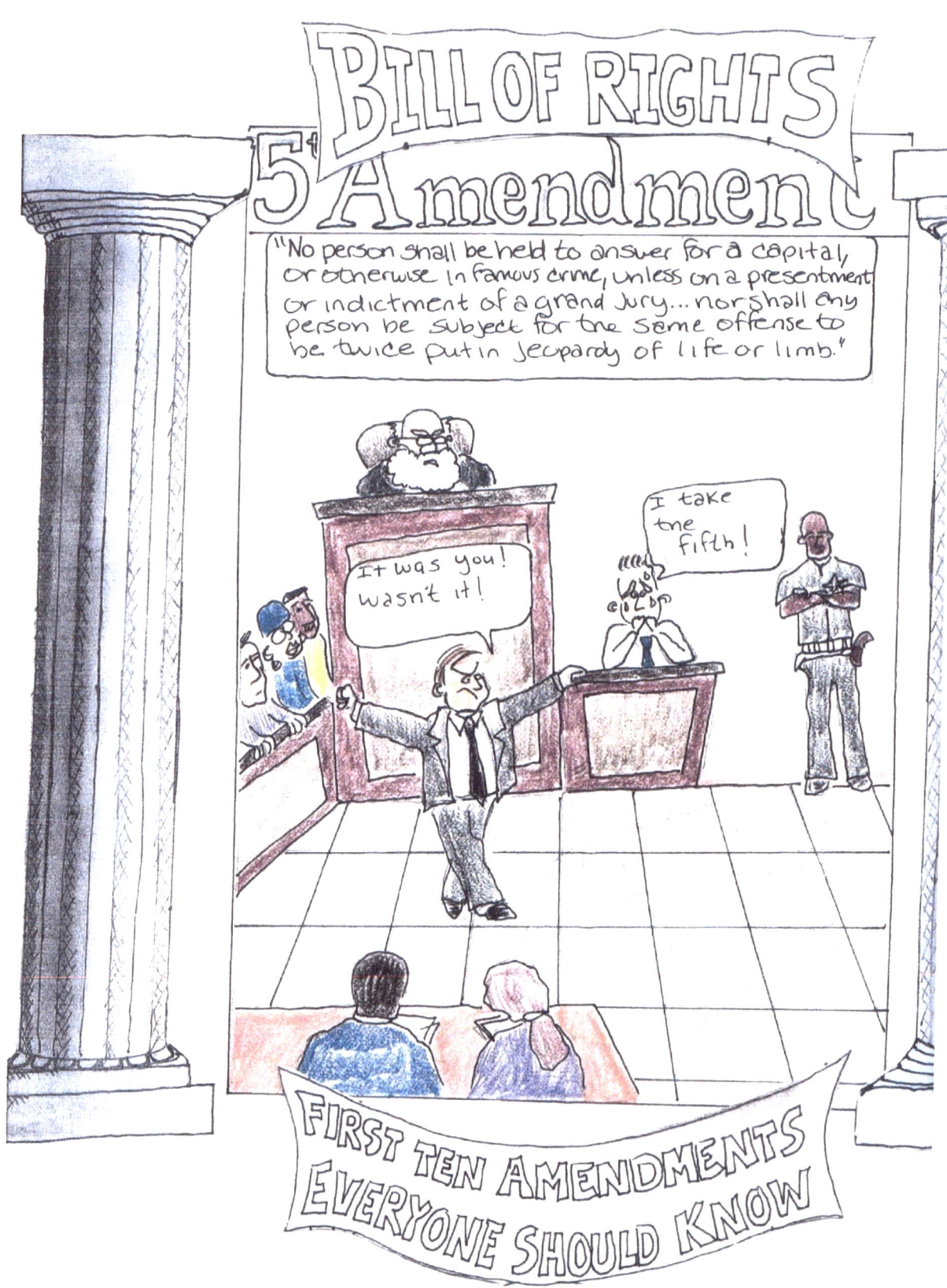

The Fifth Amendment

(Miranda Warning Rule)

The main reason for this law is that sometimes the police can seem very powerful and intimidating and it can be very frightening for a person who is mistaken for committing a crime and that person may be so scared and intimidated he will agree to whatever the police are demanding.

Normally the police will have the right person who did the crime, but sometimes they are not sure. This rule is called the Miranda warning rule. If a person is stopped and suspected of doing a crime, he or she has the right to be silent and has the right to ask for a lawyer to be present when he or she is being questioned by the police.

The lawyer will be there to make sure all the questions are fair, that the police follow the constitution properly, and that to find out the truth the citizen is treated in a just and fair way. The other part of the Fifth Amendment is called double jeopardy. This means that once a citizen is found guilty of a certain crime he cannot again be put on trial for that same crime because he has already had been tried for it. This means he cannot be punished more than once for a certain crime.

The Sixth Amendment

The Sixth Amendment was written for someone who does get arrested, but still has certain rights. These are the right to have a lawyer even if you are too poor to afford one. You always have the right to have a lawyer present to make sure the constitution is being upheld if you face any jail time

The Sixth Amendment
(Right to a Fair Trial)

The Sixth Amendment also provides for the right to a fair trial. When a suspect is on trial for a crime, everything must be very fair so that the person on trial can properly defend himself. This includes the District Attorney, who also must be fair in showing evidence that the suspect has committed the crime.

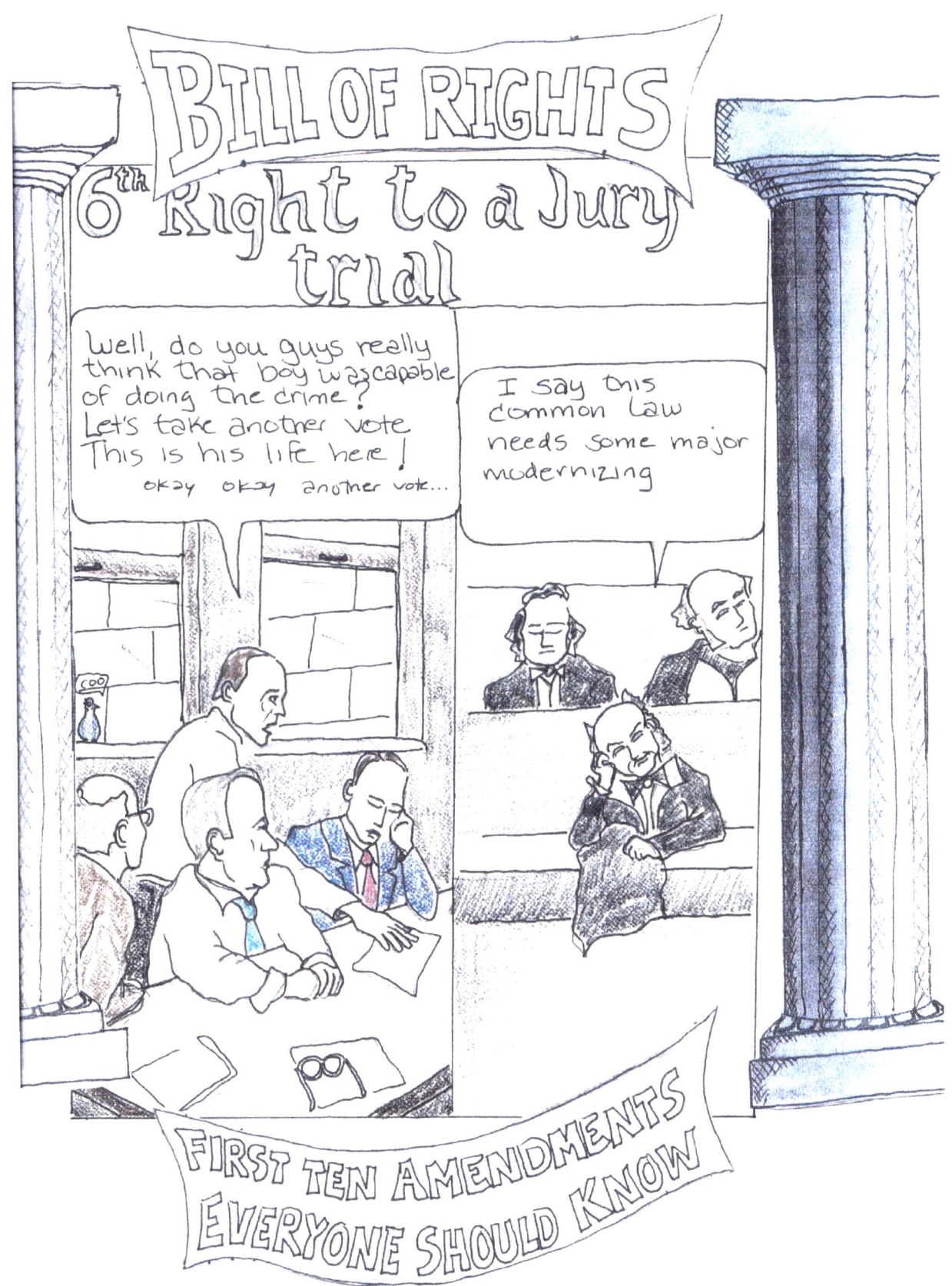

The Sixth Amendment
(Right to Speedy Trial)

For example, when there is a jury chosen the jurors must be fair and listen to all the evidence! If they are not fair an innocent person could mistakenly go to jail! That is why this is so important. Also, the Sixth Amendment provides for the right to a speedy trial, this means after you are arrested you won't stay in jail for a long time before you have your trial, it must be speedy!

A suspect also has the right to confront any witnesses who are against him. This means when people speak on the witness stand and say that they saw what happened, you have the right to ask them questions about it to make sure it is the truth!

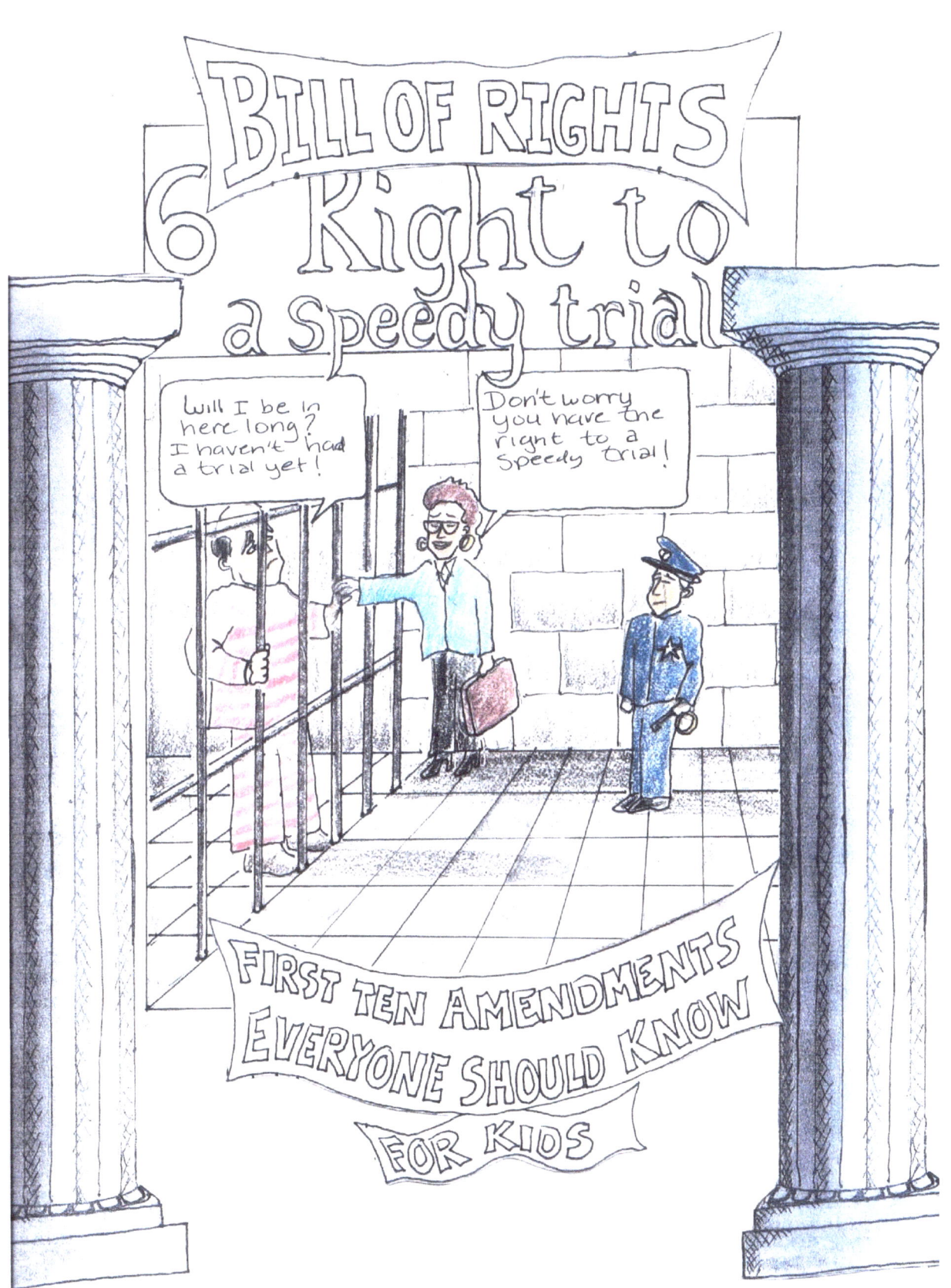

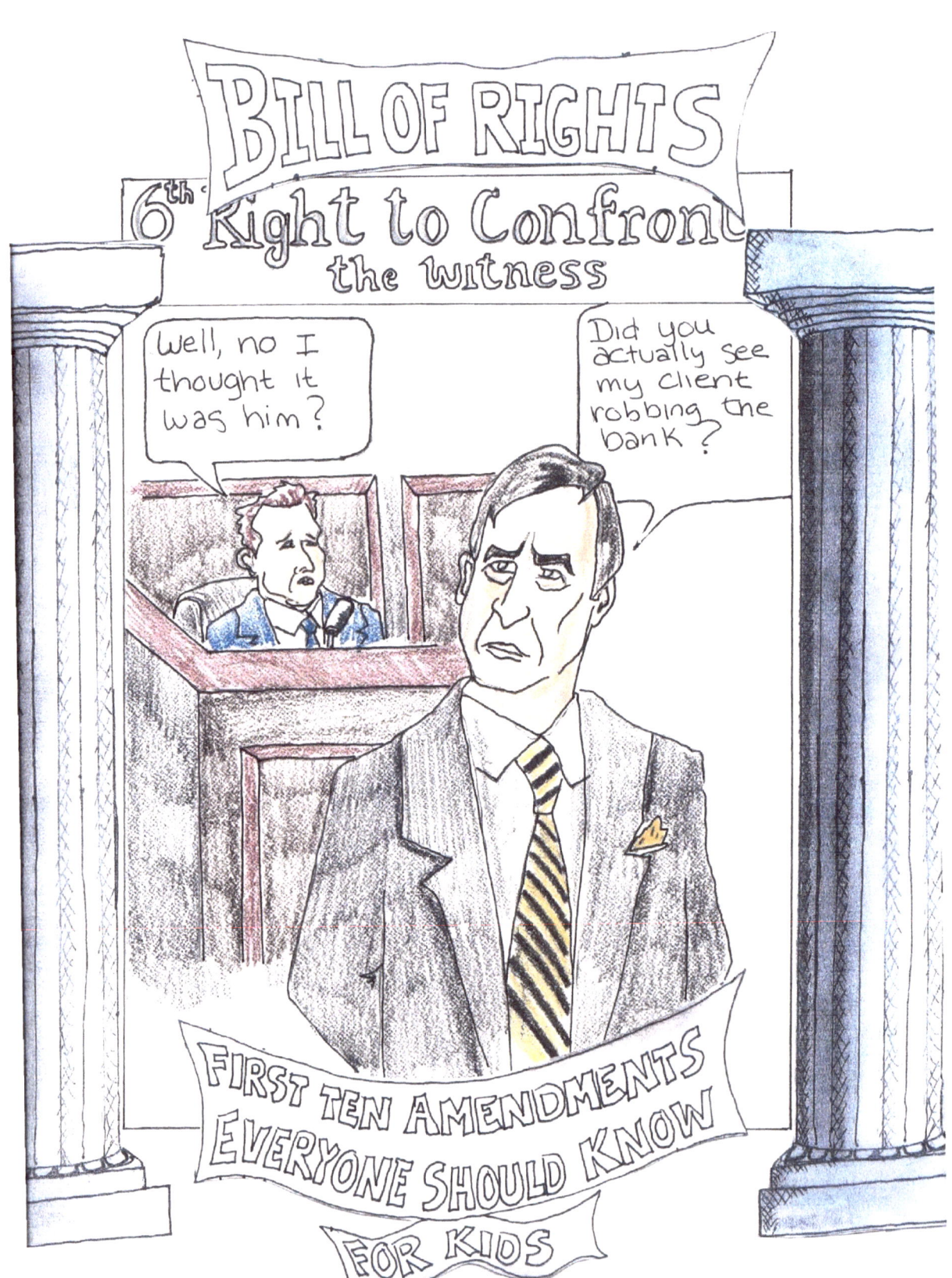

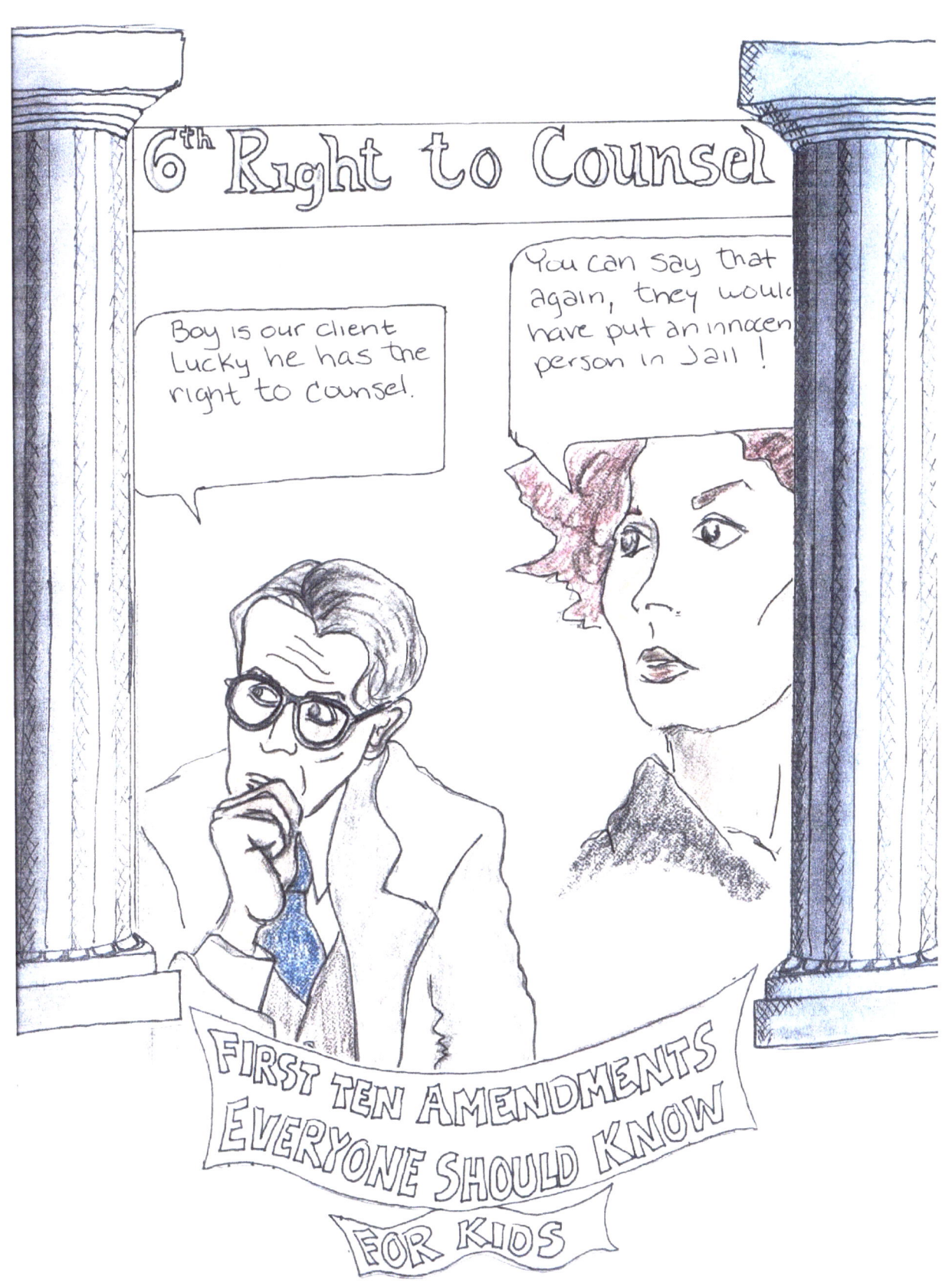

The Seventh Amendment

This amendment allows citizens to have a jury trial when they are suing each other for money damages in civil court for an amount over twenty dollars.

Civil court is where citizens who suffered injury to themselves or their property because of the fault of someone else can demand the money they lost back because of that other person's fault.

For example, if someone is not driving properly, and accidentally crashes his car into another car and then causes damages or injuries, or both, the injured victim can get his money back from that person in a civil court of law!

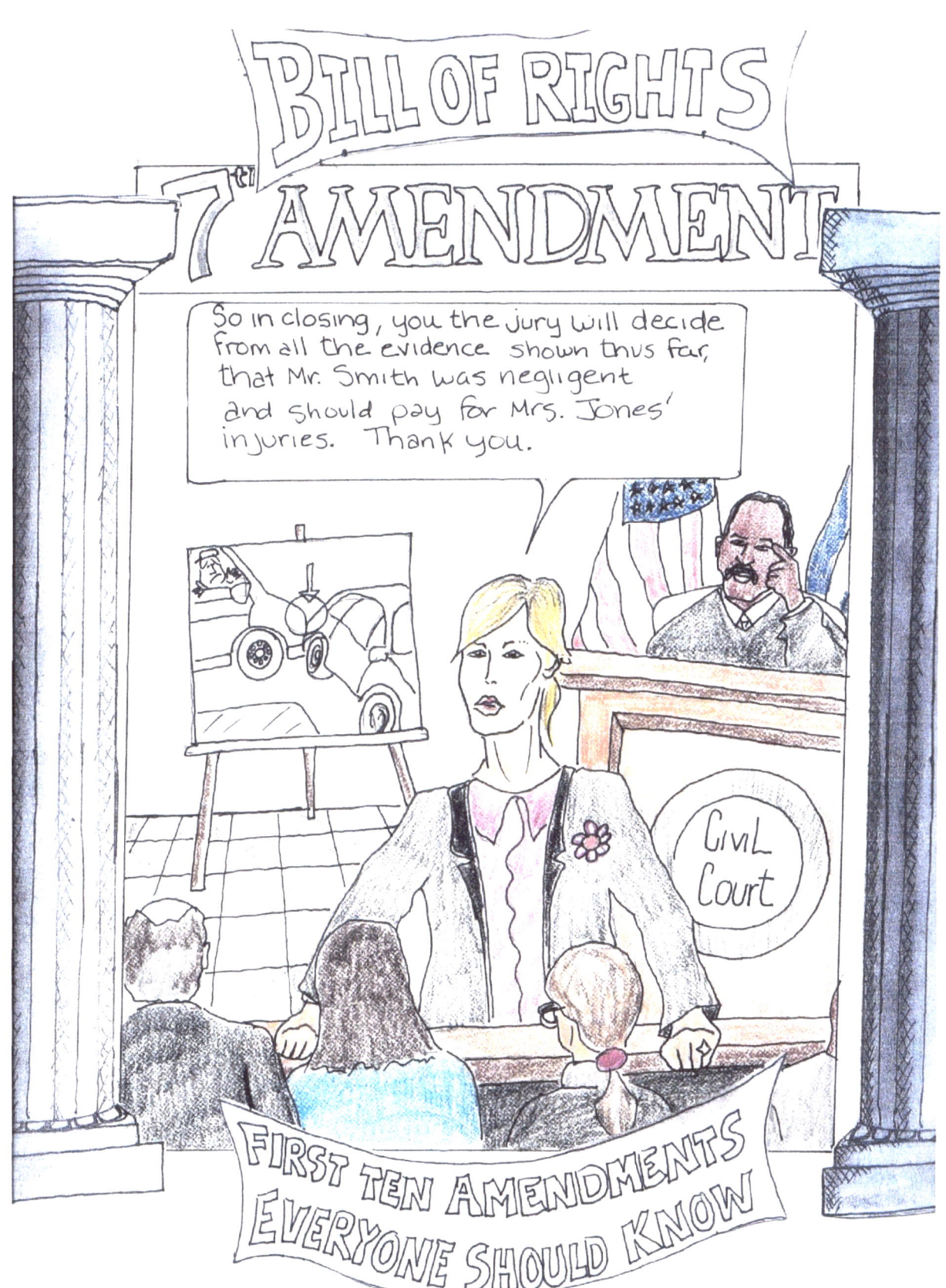

The Eighth Amendment

The Eighth Amendment guarantees that there will be no cruel or unusual punishment for people that have been charged with serious crimes.

Over two hundred years ago the criminal courts were not all using the same punishments for prisoners accused of serious crimes. This amendment prevented any kind of cruel or unusual punishment to continue happening.

The Eighth Amendment also does not allow the judge to impose excessive bail. This ensures that a person who first gets arrested can be able to afford to pay for his or her release while waiting for the trial.

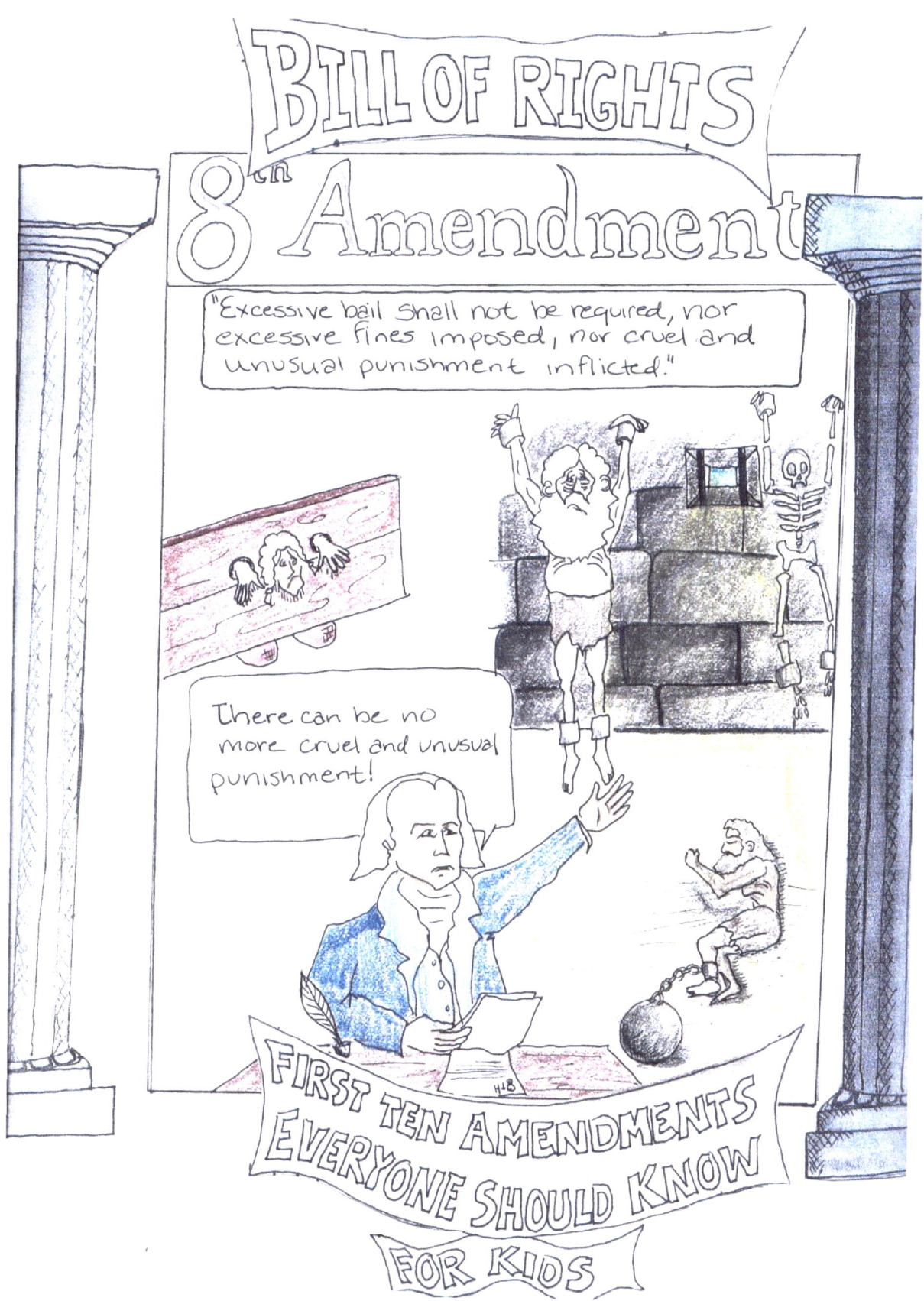

The Ninth Amendment

This is an amendment that made sure if there were any other rights that were left out that they should be applied. The court can use the Ninth Amendment to make sure there is fairness. This amendment is rarely used and in a few cases it was determined by the Supreme Court of the United States that there is a right of privacy that is implied in certain instances.

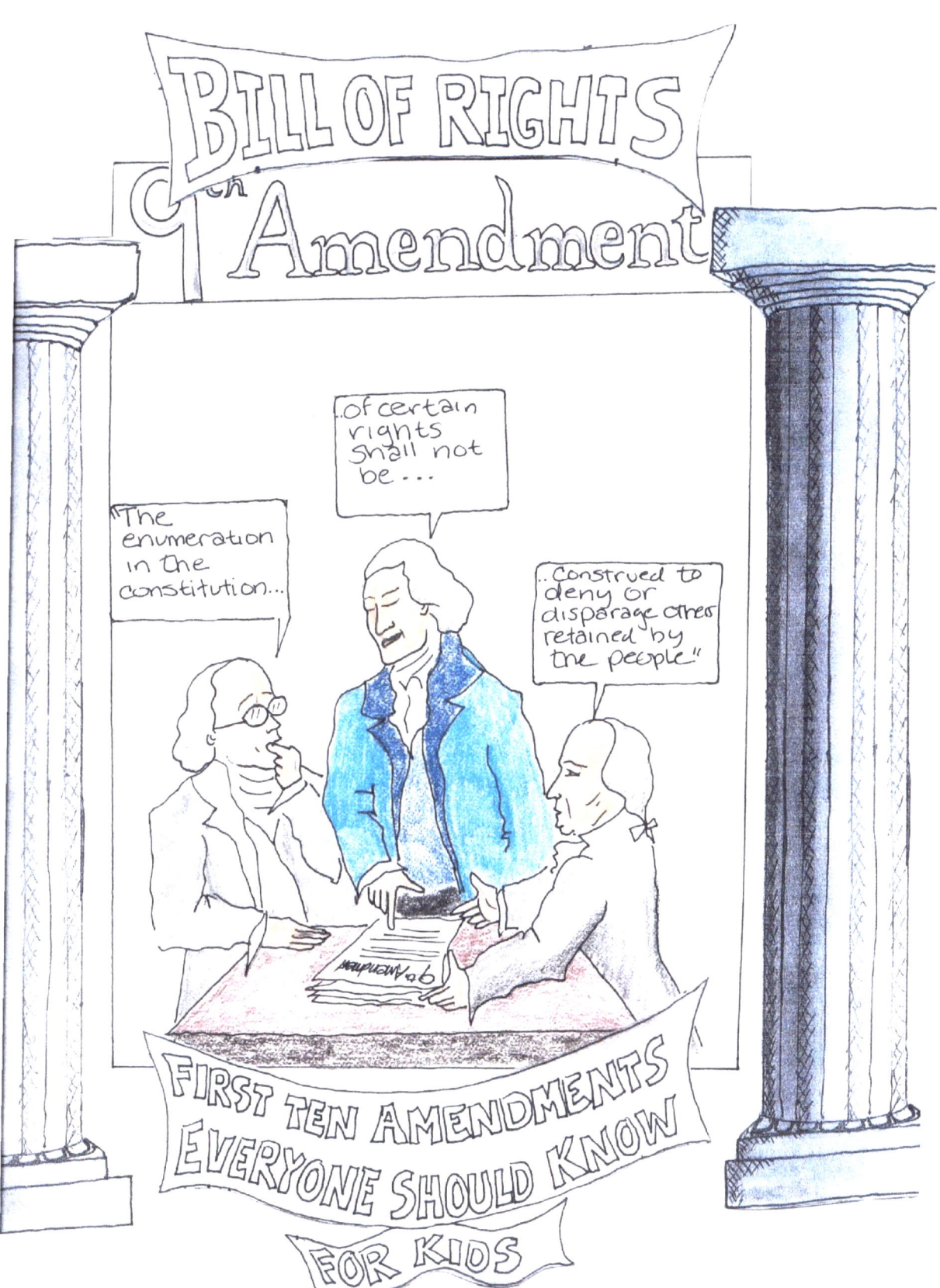

The Tenth Amendment

This important amendment is where each state gets all its constitutional power to govern itself. The Tenth Amendment allows the states to deal with their own issues only within the state itself.

The main power given is to provide police, health, welfare, and safety for the people. Each state is responsible for its own police department that protects the people within the state. Each state also has the power to protect local interests. The local interests can range from safeguarding the local beaches and water supplies to making sure it's safe for the people in the state.

It also gives the states the power to control how homes and businesses are set up and what areas they will be placed to make it easy for all the people to live and work in the local areas.

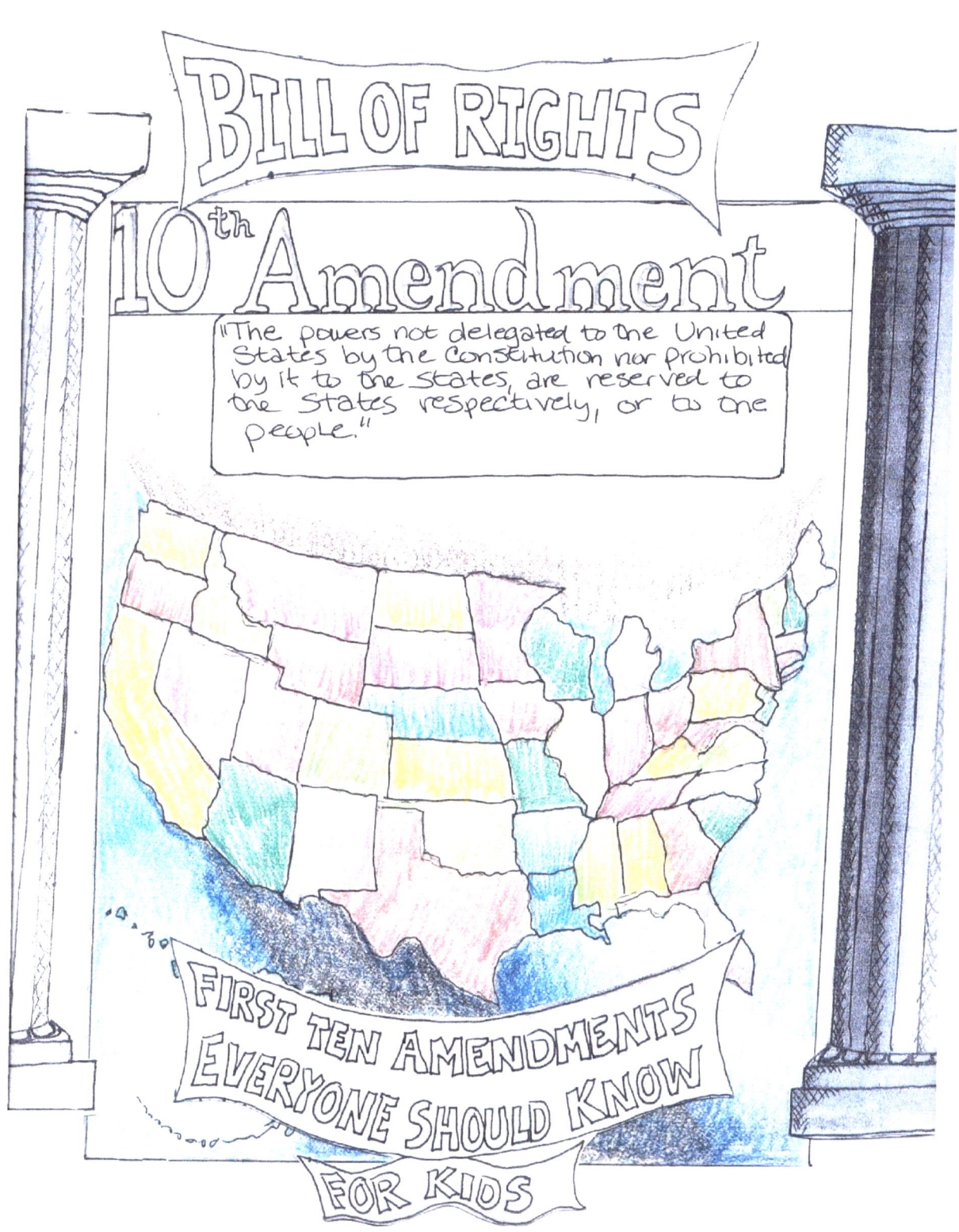

Conclusion

So now you know the first Ten Amendments, the Bill of Rights! Now that you've read about your basic rights as a United States citizen, you are on your way to being a very informed citizen by knowing the most important rights and laws that are there to protect us as citizens!

Keep this book handy to always go back and re-read an amendment. Rights such as free speech, freedom of the press, and freedom of religion, are very common and you will start noticing that these rights are all around us and affect us all in our everyday lives!

www.ingramcontent.com/pod-product-compliance
Lightning Source LLC
Chambersburg PA
CBHW051109180526
45172CB00002B/844